Heart To Heart

A BOOK OF LOVE

This Book Belongs To

David

From Michelle

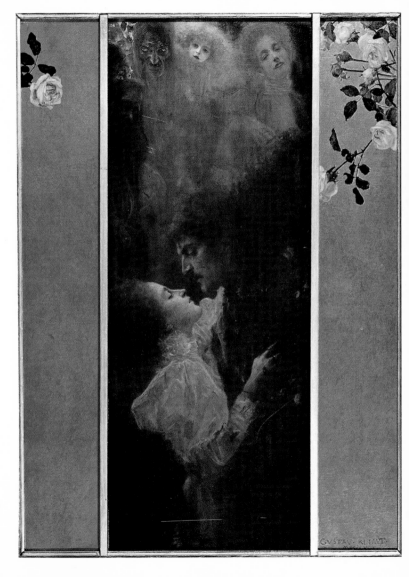

Heart To Heart

A BOOK OF LOVE

Edited by Kevin Osborn

Ariel Books

Andrews and McMeel
Kansas City

ISBN: 0-8362-4719-1

Library of Congress Catalog Card Number: 94-71136

The text of this book was set in Poetica Chancery
by Harry Chester, Inc., New York City.

Designed by Michael Mendelsohn

Illustrations: page 2: Love, Gustav Klimt, 1895; p. 6: Fulfillment, Gustav Klimt, ca. 1905; p. 9: The Lovers, Pablo Picasso, 1923; p. 17: Lovers at the Window, early 18th century; p. 21: Moonlight, Winslow Homer, 1874; p. 25: By Unfrequented Ways, William Henry Gore; p. 28: Spring in Central Park, William Zorach, 1914; p. 31: The Proposal, Adolphe William Bouguereau, 1872; p. 33: The Last Evening, James Tissot, 1873; p. 36: A letter of Love, Isaac Snowman.

CONTENTS

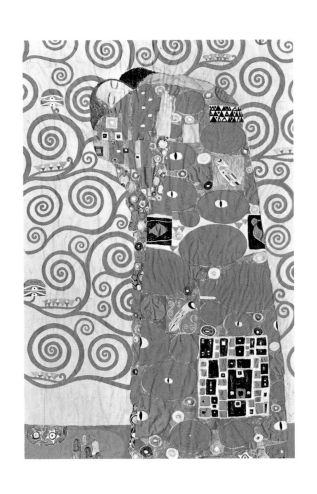

ODES TO LOVE

*To love one who loves you, to admire one who admires you,
in a word, to be the idol of one's idol, is exceeding the limit of
human joy; it is stealing fire from heaven.*

—Delphine de Girardin

*When the one man loves the one woman and the one woman
loves the one man, the very angels leave heaven and come
and sit in that house and sing for joy.*

—Brahma

*O lyric Love, half angel and half bird,
And all a wonder and a wild desire!*

—Robert Browning

Love is something like the clouds that were in the sky before
the sun came out. You cannot touch the clouds, you know;
but you feel the rain and know how glad the flowers
and the thirsty earth are to have it after a hot day.
You cannot touch love either; but you feel the sweetness
that it pours into everything.

—Annie Sullivan

The fountains mingle with the river,
And the rivers with the ocean;
The winds of heaven mix for ever
With a sweet emotion;
Nothing in the world is single;
All things, by a law divine,
In one another's being mingle—
Why not I with thine?

—Percy Bysshe Shelley

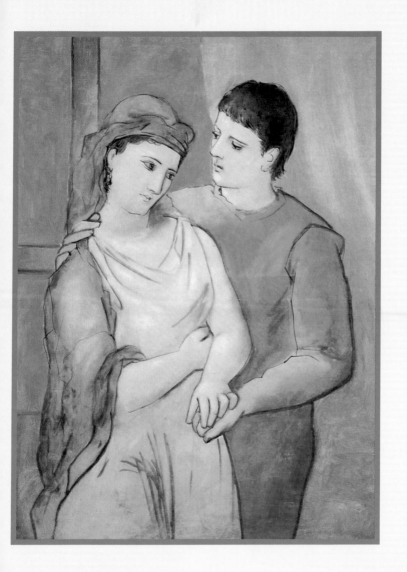

Breathless, we flung us on the windy hill,
Laughed in the sun, and kissed the lovely grass.

—Rupert Brooke

As an apple tree among the trees of the wood,
so is my beloved among young men.
I delighted and sat down under his shadow,
and his fruit was sweet to my taste.
He brought me to the house of wine,
and his banner over me was love.

—Song of Solomon

To be together is for us to be at once as free as in solitude, as
gay as in company. We talk, I believe, all day long: to talk to
each other is but a more animated and an audible thinking.

—Charlotte Brontë

Doubt that the stars are fire;
Doubt that the sun doth move;
Doubt truth to be a liar;
But never doubt I love.

— William Shakespeare

… I asked him with my eyes to ask again yes and then he
asked me would I yes to say yes my mountain flower and first
I put my arms around him yes and drew him down to me so
he could feel my breasts all perfume yes and his heart was
going like mad and yes I said yes I will Yes.

— James Joyce

… Love is not love
Which alters when it alteration finds,
Or bends with the remover to remove:
O, no! it is an ever-fixed mark
That looks on tempests and is never shaken.

— William Shakespeare

It seems that it is madder never to abandon one's self than often to be infatuated; better to be wounded, a captive and a slave, than always to walk in armor.

—Margaret Fuller

I think true love is never blind,
But rather brings an added light,
An inner vision quick to find
The beauties hid from common sight.

—Phoebe Cary

It is difficult to define love; what can be said is that in the soul it is a passion to dominate another, in the mind it is a mutual understanding, whilst in the body it is simply a delicately veiled desire to possess the beloved after many rites and mysteries.

—François de La Rochefoucauld

LOVE LINES

In our life there is a single color, as on an artist's palette,
which provides the meaning of life and art.
It is the color of love.

—Marc Chagall

Love that's wise
Will not say all it means.

—Edwin Arlington Robinson

O love is the crooked thing,
There is nobody wise enough
To find out all that is in it,
For he would be thinking of love
Till the stars had run away
And the shadows eaten the moon.

—William Butler Yeats

This is one of the miracles of love: It gives …
a power of seeing through its own enchantments and
yet not being disenchanted.

—C. S. Lewis

Love is the source of language, and also its destroyer.

—Isabel G. MacCaffrey

Whatever our souls are made of, his and mine are the same.

—Emily Brontë

Two souls with but a single thought,
Two hearts that beat as one.

—Friedrich Halm

I like not only to be loved, but to be told I am loved.

—George Eliot

There isn't any formula or method. You learn to love by loving—by paying attention and doing what one thereby discovers has to be done.

—Aldous Huxley

Say "I love you" to those you love. The eternal silence is long enough to be silent in.

—George Eliot

If we all discovered that we had only five minutes left to say all that we wanted to say, every telephone booth would be occupied by people calling other people to tell them that they loved them.

—Christopher Morley

Love is what you've been through with somebody.

—James Thurber

There is no fear in love; but perfect love casteth out fear.

—*I John 4:18*

Tears may be dried up, but the heart—never.

—*Marguerite de Valois*

*Love is like a beautiful flower which I may not touch,
but whose fragrance makes the garden a place of
delight just the same.*

—*Helen Keller*

We can only learn to love by loving.

—*Iris Murdoch*

*With you there is life and joy and peace and all good
things—away from you there is turmoil and anguish
and blank despair.*

—*Bertrand Russell*

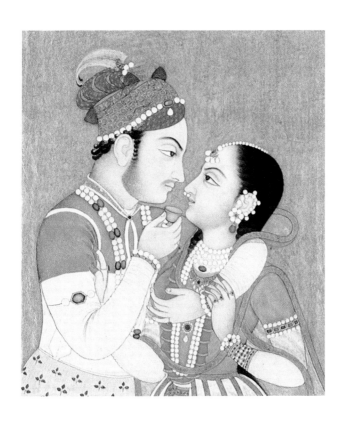

Love lights more fires than hate extinguishes.

—*Ella Wheeler Wilcox*

Love seeks not to possess, but to be possessed.

—*R. H. Benson*

Love does not consist in gazing at each other but in looking together in the same direction.

—*Antoine de Saint-Exupéry*

When you love someone all your saved-up wishes start coming out.

—*Elizabeth Bowen*

Is it not by love alone that we succeed in penetrating to the very essence of a being?

—*Igor Stravinsky*

One cannot be strong without love. For love is not an irrelevant emotion; it is the blood of life, the power of reunion of the separated.

—Paul Tillich

Love is an energy which exists of itself. It is its own value.

—Thornton Wilder

Keep love in your heart. A life without it is like a sunless garden when the flowers are dead. The consciousness of loving and being loved brings a warmth and richness to life that nothing else can bring.

—Oscar Wilde

Familiar acts are beautiful through love.

—Percy Bysshe Shelley

Love doesn't just sit there like a stone; it has to be made,
like bread, remade all the time, made new.

—Ursula K. Le Guin

Love doesn't grow on the trees like apples in Eden—
it's something you have to make. And you must use your
imagination to make it too, just like anything else.
It's all work, work.

—Joyce Cary

To love deeply in one direction makes us more loving
in all others.

—Madame Swetchine

The story of a love is not important—what is important is
that one is capable of love. It is perhaps the only glimpse we
are permitted of eternity.

—Helen Hayes

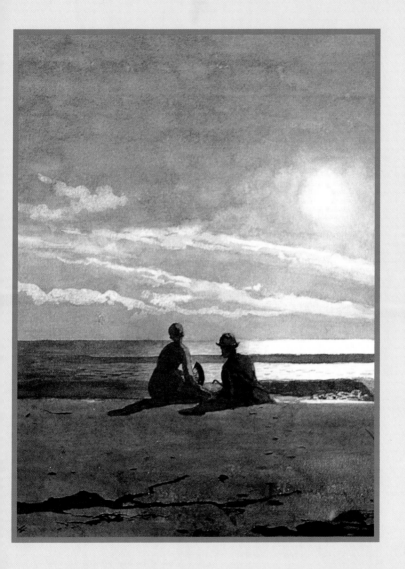

Whoso loves believes the impossible.

—Elizabeth Barrett Browning

To love is to receive a glimpse of heaven.

—Karen Sunde

To love a person means to agree to grow old with him.

—Albert Camus

To love is to admire with the heart;
to admire is to love with the mind.

—Théophile Gautier

Take away love and our earth is a tomb.

—Robert Browning

LOVE STORIES

*As a young music student, tenor Lauritz Melchior was sitting
in his Munich garden rehearsing a role. "Come to me, my love,
on the wings of light," he sang. To his amazement, a woman
flew down and landed at his feet. She was Maria Hacker, an
actor shooting a stunt for a movie, and had parachuted into
Melchior's garden. Guided by heaven or dropped by chance? It
hardly mattered: romance, love, and marriage followed.*

*[My wife] told me one of the sweetest things one could hear—
"I am not jealous. But I am truly sad for all the actresses who
embrace you and kiss you while acting, for with them, you are
only pretending."*

<div align="right">—Joseph Cotten</div>

During his courtship of Elizabeth Barrett, Robert Browning decided to ask the books in his library where his love would lead. At random, he pulled an Italian grammar book from a shelf—not a particularly promising beginning. Yet the translation exercise he opened to revealed all in this sentence: "If we love in the other world as we do in this, I shall love thee to eternity."

Gleeful over his apparent victory over Harry Truman in the 1948 presidential election, Thomas Dewey asked his wife, Frances, how she felt about sleeping with the president of the United States, to which Frances replied that she was looking forward to the high honor. In a stunning upset, however, Dewey lost the election. Over breakfast the next morning, Mrs. Dewey tried to lift her husband's spirits. "Tell me, Tom," she asked, "am I going to Washington or is Harry coming here?"

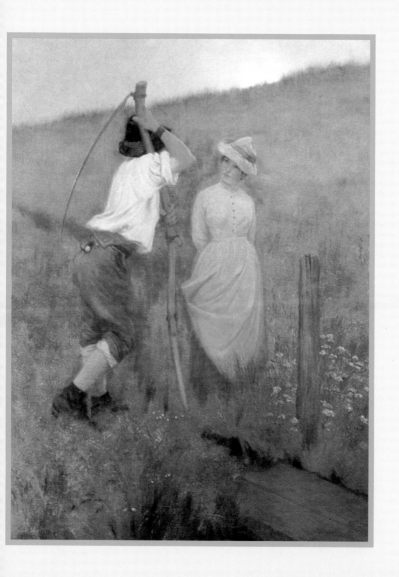

Edward VIII, who abdicated his throne for the love of American divorcée Wallis Warfield Simpson, joined a group of friends discussing ways to maintain a good standing with one's wife. Edward admitted to having a slight edge. "It helps," he said, "to be able to remind your bride that you gave up a throne for her."

At a dinner party, Joseph Choate, U.S. ambassador to Great Britain at the turn of the century, demonstrated both his mastery of diplomacy and his undying romanticism. Asked who he would want to be other than himself, Choate thought for a moment, smiled at his wife, and replied, "If I could not be myself, I would like to be Mrs. Choate's second husband."

At age thirty-five, member of Parliament and future British prime minister Benjamin Disraeli married Mary Anne Wyndham Lewis, a wealthy widow twelve years older than he. Throughout their thirty-three years together, Disraeli couldn't resist teasing his wife that he had married her for her fortune. "Ah, yes, I know," she would reply, "but if you had the chance to do it again, you'd do it for love!"

As the producer of the popular TV show "Talent Scouts," Irving Mansfield was besieged with requests for auditions. One enterprising talent sent a suggestive photo of herself with a letter explaining she would do anything to get on his show: "And when I say anything, I mean anything."

Mansfield's wife, novelist Jacqueline Susann, happened to open the letter and wrote back, "I am Mrs. Mansfield, and I do everything for my husband. And when I say everything, I mean everything."

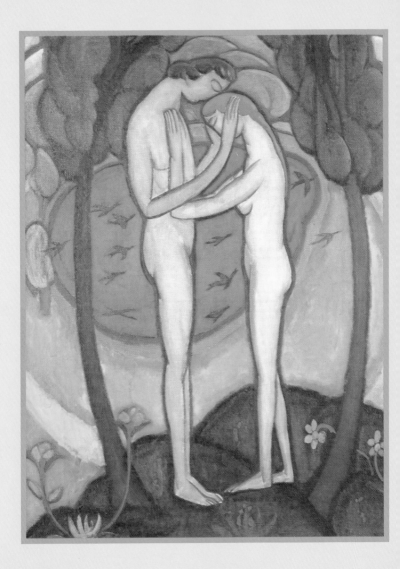

LOVE LETTERS

To George Sand (1833)

*(pen name of Amandine Aurore Lucie Dupin,
Baronne Dudevant)*

My dear George,

I have something stupid and ridiculous to tell you . . . I am
in love with you . . . I thought I should cure myself in seeing
you quite simply as a friend. . . . But I pay too dearly for the
moments I pass with you . . . I know how you think of me,
and I have nothing to hope for in telling you this. I can only
foresee losing a friend and the only agreeable hours I have passed
for a month. But I know that you are kind, that you have loved,
and I put my trust in you, not as a mistress, but as a frank
and loyal comrade.

—Alfred de Musset

To Clara Schumann (1838)

What a heavenly morning! All the bells are ringing; the sky is so golden and blue and clear—and before me lies your letter. I send you my first kiss, beloved.

—*Robert Schumann*

To Fanny Brawne (1820)

Sweetest Fanny,

You fear, sometimes, I do not love you so much as you wish? My dear Girl I love you ever and ever and without reserve. The more I have known you the more have I lov'd. . . . You are always new. The last of your kisses was ever the sweetest; the last smile the brightest; the last movement the gracefullest.

—*John Keats*

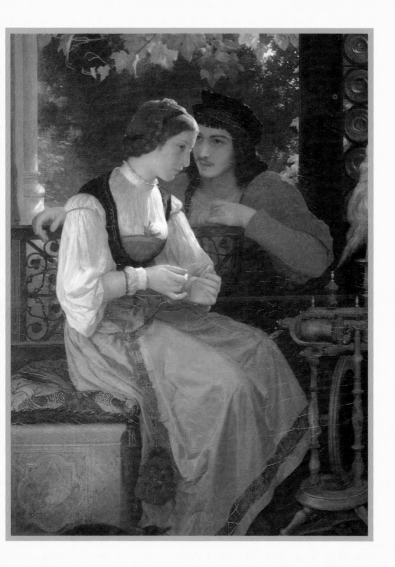

To Nora Barnacle Joyce (1909)

. . . Nora, I love you. I cannot live without you. . . . I would like to go through life side by side with you, telling you more and more until we grew to be one being together until the hour should come for us to die. Even now the tears rush to my eyes and sobs choke my throat as I write this. . . . O my darling be only a little kinder to me, bear with me a little even if I am inconsiderate and unmanageable and believe me we will be happy together. Let me love you in my own way. Let me have your heart always close to mine to hear every throb of my life, every sorrow, every joy.

—James Joyce

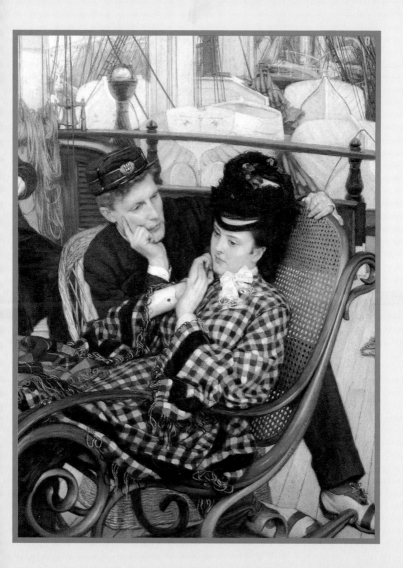

To Adèle Foucher (1821)

When two souls, which have sought each other for however long in the throng, have finally found each other ... a union, fiery and pure as they themselves are ... begins on earth and continues for ever in heaven. This union is love, true love, ... a religion, which deifies the loved one, whose life comes from devotion and passion, and for which the greatest sacrifices are the sweetest delights. This is the love which you inspire in me. ... Your soul is made to love with the purity and passion of angels; but perhaps it can only love another angel, in which case I must tremble with apprehension.

—*Victor Hugo*

To Anne Boleyn (1528)

My Mistress and Friend,

I and my heart put ourselves in your hands, begging you to recommend us to your good grace and not to let absence lessen your affection.... [F]or myself the pang of absence is already too great, and when I think of the increase of what I must needs suffer it would be well nigh intolerable but for my firm hope of your unchangeable affection ...

—*Henry VIII*

To Josephine Bonaparte (1796)

I have not spent a day without loving you; I have not spent a night without embracing you; I have not so much as drunk a single cup of tea without cursing the pride and ambition which force me to remain separated from the moving spirit of my life. In the midst of my duties, whether I am at the head of my army or inspecting the camps, my beloved Josephine stands alone in my heart, occupies my mind, fills my thoughts.

—*Napoleon Bonaparte*

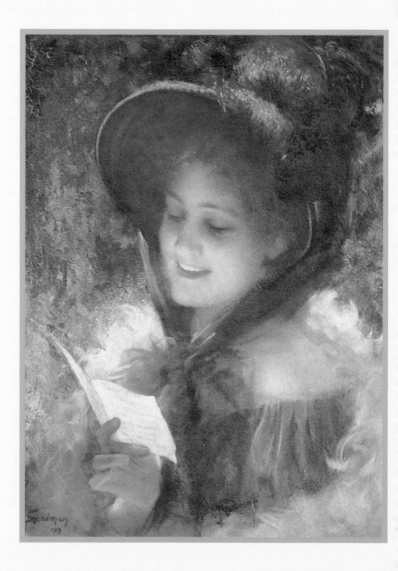

To Olivia Langdon (1869)

Livy dear, I have already mailed to-day's letter, but I am so proud of my privilege of writing the dearest girl in the world whenever I please, that I must add a few lines if only to say I love you, Livy. For I do love you, Livy—as the dew loves the flowers; as the birds love the sunshine; as the wavelets love the breeze; as mothers love their first-born; as memory loves old faces; as the yearning tides love the moon; as the angels love the pure in heart. . . .

. . . Take my kiss & my benediction, & try to be reconciled to the fact that I am

Yours, forever & always.

Sam

P.S.—I have read this letter over & it is flippant, & foolish & puppyish. I wish I had gone to bed when I got back, without writing. You said I must never tear up a letter after writing it to you—& so I send it. Burn it, Livy—I did not think I was writing so clownishly and shabbily. I was in much too good a humor for sensible letter writing.

—Samuel Clemens (Mark Twain)

A LOVER'S MISCELLANY

Place a peapod with nine peas in it under the kitchen door. The next person to come in—or someone with the same name as that person—will be your true love.

Catch a ladybug, then let it fly away. It will invariably fly in the direction of your true love.

Name an apple seed or a nut after your love and place it in a fire. If it pops, you are loved; if it burns without a sound, your love cares little.

Tomatoes, once called love apples, were considered so powerful an aphrodisiac that Puritans were not allowed to even put them on the dinner table.

Avocados were thought by the Aztecs to aid virility—to the extent that virgins didn't leave their houses while the fruit was being harvested.

Honey, known as "the nectar of the gods," with its thick, sensual sweetness, has long been a food of love. It figures prominently in the following passage from the Hindu marriage ritual "Seven Steps":

> May the nights be honey-sweet for us;
> may the mornings be honey-sweet for us;
> may the earth be honey-sweet for us;
> may the heavens be honey-sweet for us.
>
> May the plants be honey-sweet for us;
> may the sun be all honey for us;
> may the cows yield us honey-sweet milk!

A kiss is not just a kiss according to
this catalog of kisses from the Kama Sutra:

The nominal kiss

The throbbing kiss

The touching kiss

The straight kiss

The bent kiss

The turned kiss

The greatly pressed kiss

The kiss of the upper lip

The clasping kiss

The kiss that kindles

The kiss that turns away

The kiss that awakens

The kiss showing the intention

The transferred kiss

The demonstrative kiss

—Adapted from "On Kissing" from The Kama Sutra of Vatsyayana